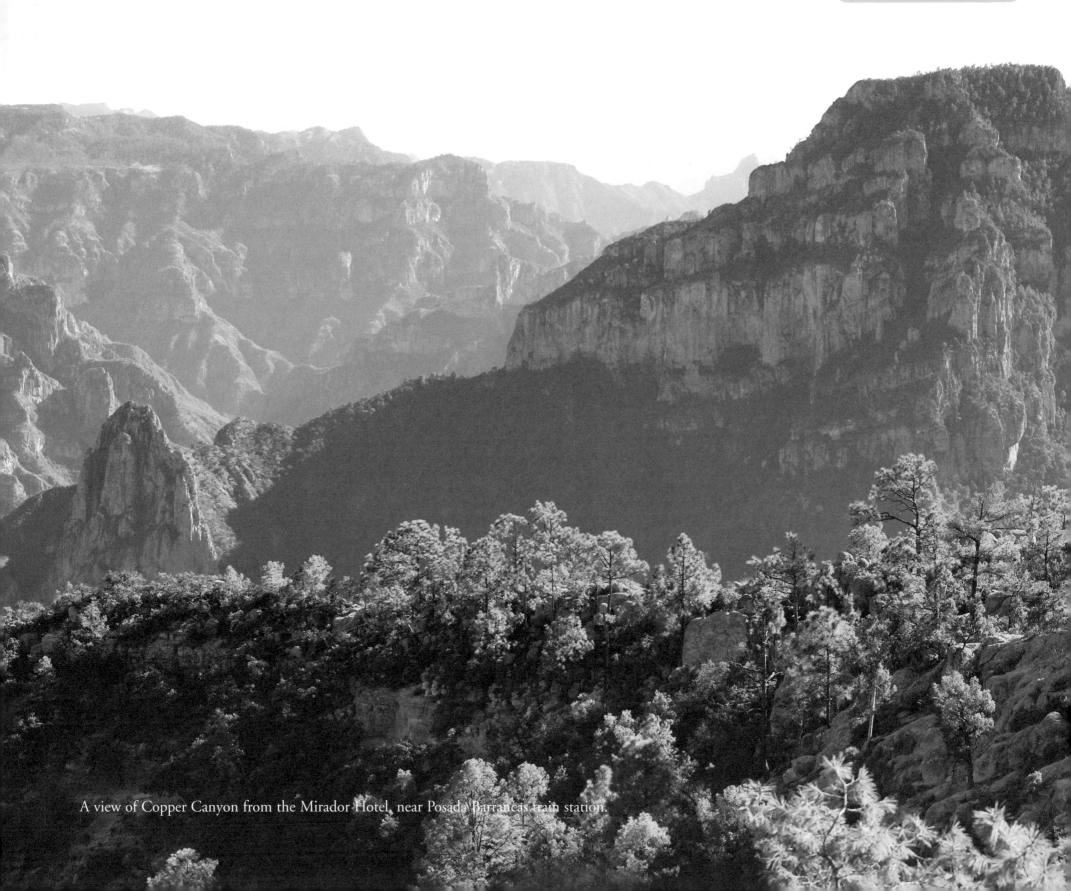

A view of Copper Canyon from the Mirador Hotel, near Posada Barrancas train station.

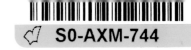

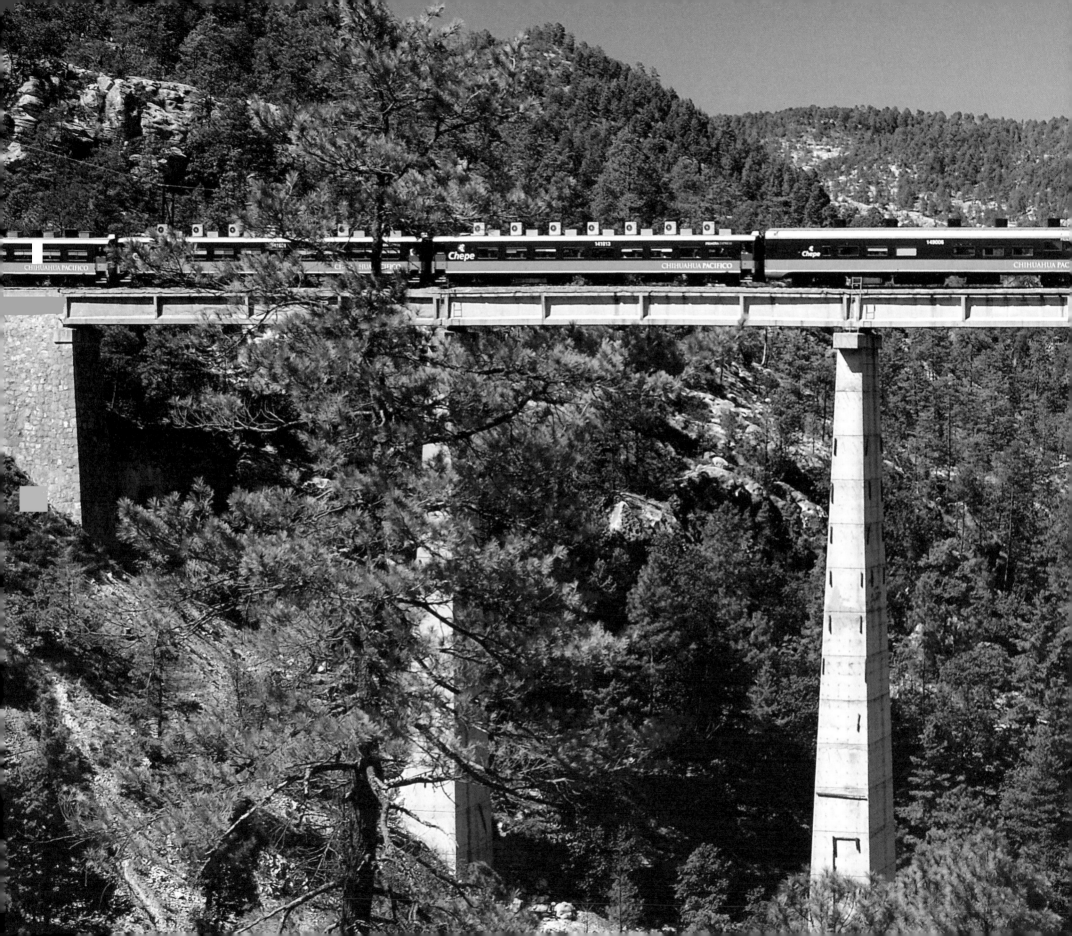

The "Chepe" — Chihuahua al Pacífico railroad — crosses the 695-foot-long La Laja bridge at km 639.

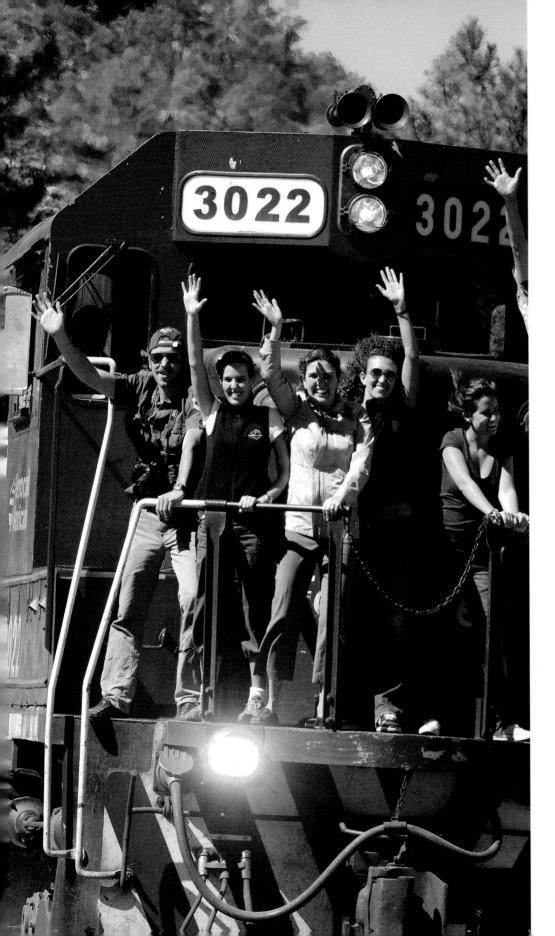

COPPER CANYON

Published by Bernardo Balderrama Garcia; photographs by Christian Heeb; text, map, layout and production by Andrew Hudson / Photo Tour Books, Inc. First published May 2009.

ISBN: 978-1-930495-17-3

To order more books, call 866-853-0571 / 011 52-668-815-76-68 or email coppercanyonbook@mexicoscoppercanyon.com

To license these images, please visit heebphoto.com

Cameras used: Nikon F5, Asahi Pentax 6x7, Nikon F100, Nikon F90s, Nikon Coolpix 5000, Nikon D1-X.

All photos by Christian Heeb except:

Headshot on jacket flap: carlondigital.com.
Page 7, bottom-right (train); page 9, ladies; page 10, dolphins: Guadalupe Guierrez;
Page 11, Zorro statue: Bernardo Balderrama Garcia.

Cover photo: Urique Canyon near Cerocahui.

Left: Riding the "Chepe." *Right:* Copper Canyon from Mirador Hotel at Posada Barrancas.

This book is dedicated to God, who created this beautiful land with its eyes wide open. Also to my wife, Adriana, my mother, Vilma, and my father, Roberto Balderrama Gomez, the greatest believer and promoter of Copper Canyon ever. With all the respect and pride to one of the greatest and strongest races of human kind, the Tarahumara people, keepers of the canyons.

Produced by:
Photo Tour Books, Inc.
9582 Vista Tercera
San Diego CA 92129
Tel: 858-780-9726
phototourbooks.com

Distributed to the trade by:
National Book Network
(NBN), tel: 800-462-6420.
Lanham MD 20706
nbnbooks.com

First edition, first print, 2009.
Photos (except where noted)
© 2009 Christian Heeb.
Text and map © Andrew Hudson / Photo Tour Books.

Printed in Singapore by Imago.

Copper Canyon

Bernardo Balderrama Garcia

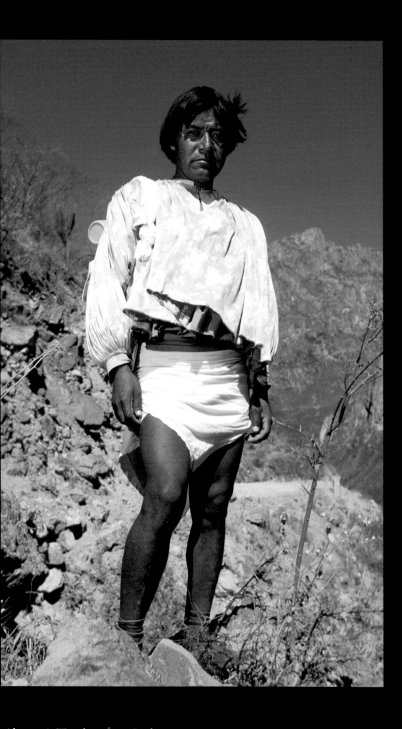

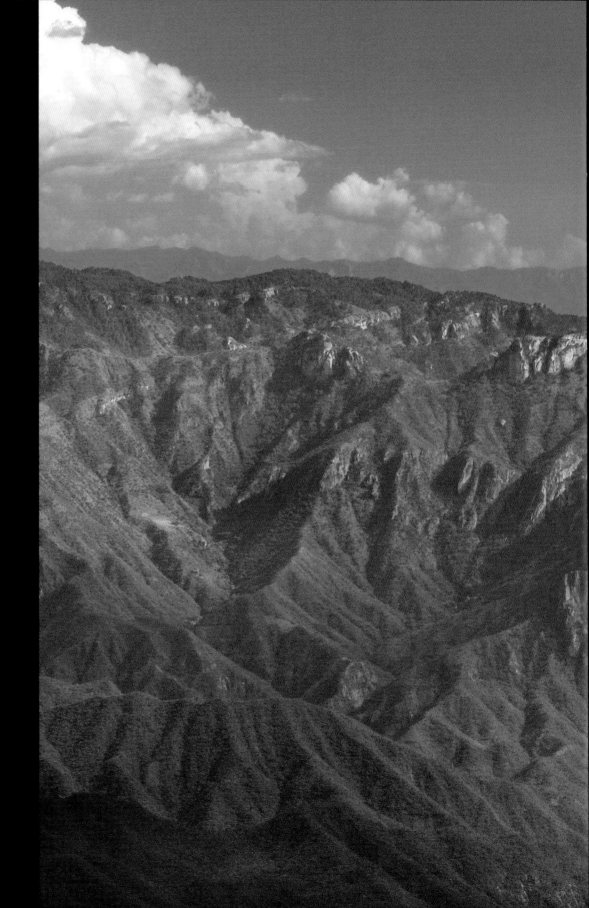

Above: A Tarahumara Indian man.
Right: Mirador Cerro del Gallego near Cerocahui.

CONTENTS

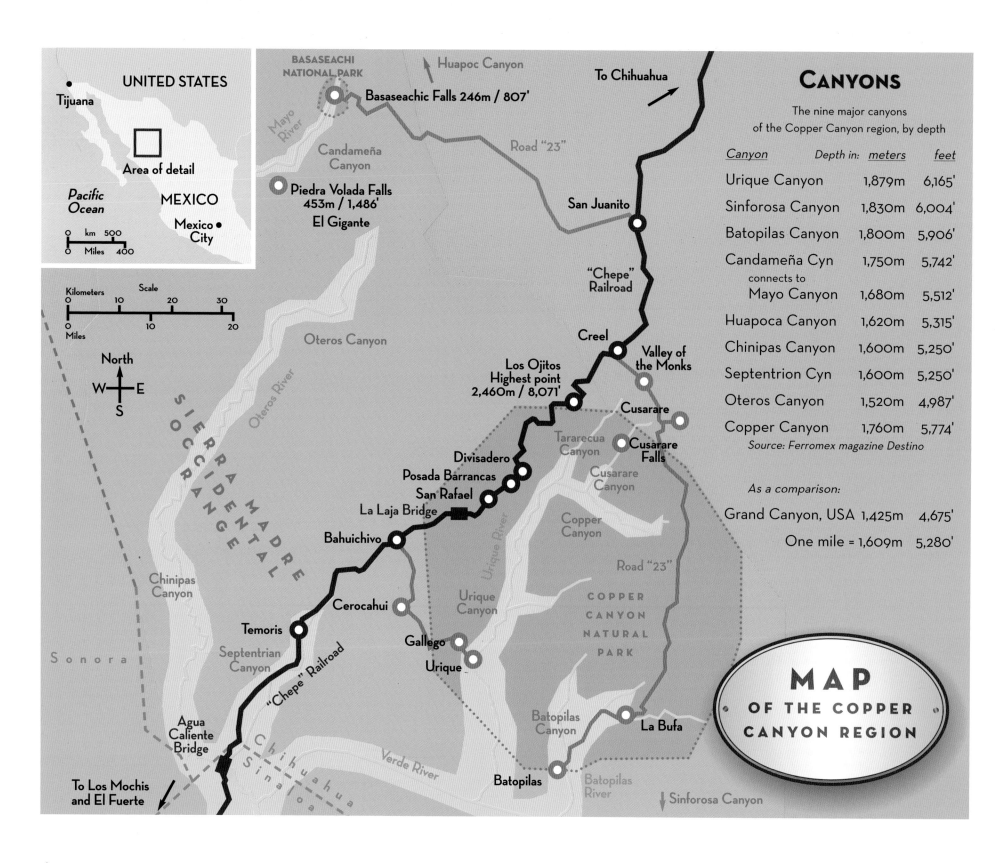

United States
Tijuana
Area of detail
Pacific Ocean
MEXICO
Mexico City

km 500
Miles 400

Kilometers Scale
10 20 30

Miles
10 20

North
W — E
S

BASASEACHI NATIONAL PARK
Basaseachic Falls 246m / 807'
Huapoc Canyon
To Chihuahua

Mayo River
Candameña Canyon
Piedra Volada Falls 453m / 1,486'
El Gigante

Road "23"
San Juanito

Oteros Canyon
Oteros River

"Chepe" Railroad

Creel
Valley of the Monks

Los Ojitos Highest point 2,460m / 8,071'
Cusarare

Tararecua Canyon
Cusarare Falls

Divisadero
Posada Barrancas
San Rafael
La Laja Bridge

Cusarare Canyon

Copper Canyon

Bahuichivo

SIERRA MADRE OCCIDENTAL RANGE

Chinipas Canyon

Urique River

COPPER CANYON NATURAL PARK

Road "23"

Cerocahui
Gallego
Urique

Urique Canyon

Temoris

Sonora

Septentrian Canyon

"Chepe" Railroad

Batopilas Canyon
La Bufa

Agua Caliente Bridge

Chihuahua
Sinaloa

Verde River

Batopilas

Batopilas River

Sinforosa Canyon

To Los Mochis and El Fuerte

CANYONS

The nine major canyons of the Copper Canyon region, by depth

Canyon	Depth in:	meters	feet
Urique Canyon		1,879m	6,165'
Sinforosa Canyon		1,830m	6,004'
Batopilas Canyon		1,800m	5,906'
Candameña Cyn		1,750m	5,742'
connects to			
Mayo Canyon		1,680m	5,512'
Huapoca Canyon		1,620m	5,315'
Chinipas Canyon		1,600m	5,250'
Septentrion Cyn		1,600m	5,250'
Oteros Canyon		1,520m	4,987'
Copper Canyon		1,760m	5,774'

Source: Ferromex magazine Destino

As a comparison:

Grand Canyon, USA	1,425m	4,675'
One mile =	1,609m	5,280'

MAP
OF THE COPPER CANYON REGION

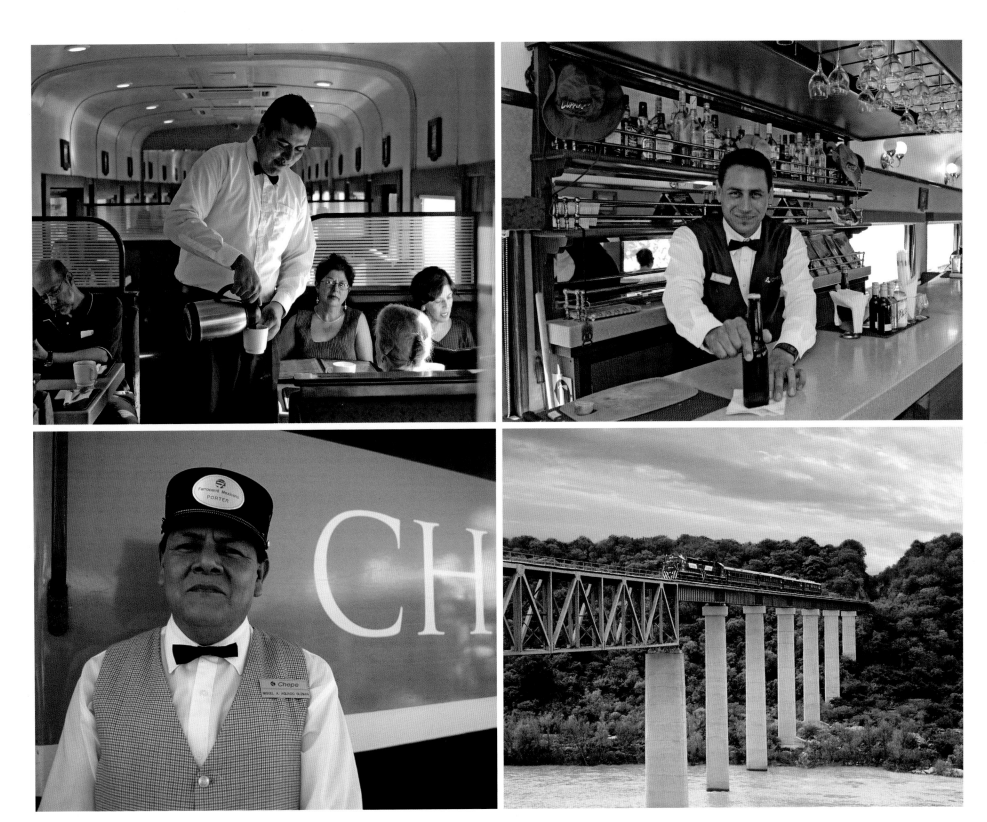

Faces of the Chepe railroad: Waiter, porter and barman.

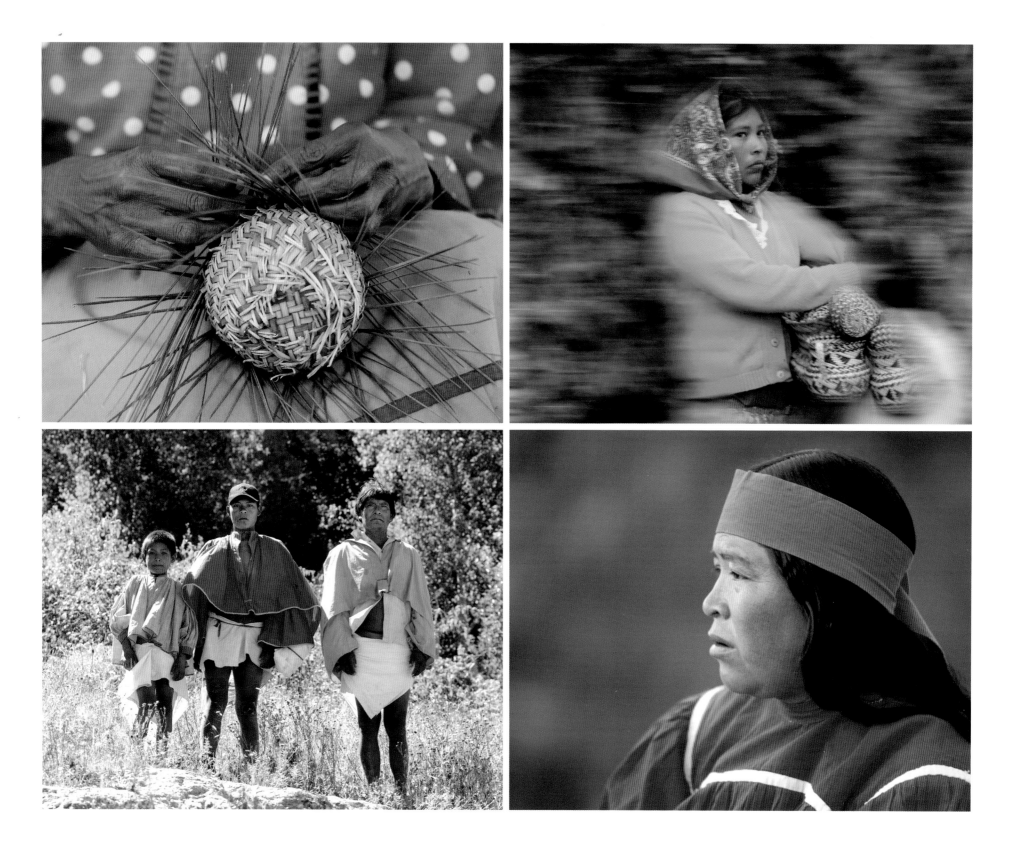

INTRODUCTION

"Beautiful lily, in bloom this morning, guard me. Drive away sorcery. Make me grow old. Let me reach the age at which I have to take up a walking stick. I thank you for exhaling your fragrance there, where you are standing."
—A Tarahumara prayer

In northwest Mexico, by the Sea of Cortés, the El Fuerte River flows gently, belying the wonders it has wrought. Pouring from coastal mountains, these waters helped carve some of the world's deepest gorges, fed a primitive yet remarkable people, and tumbled from magnificent waterfalls in alpine forests. This is the journey we shall take.

Copper Canyon (*Barranca del Cobre* in Spanish) is a spectacular region of over 20 canyons in nine systems. Named for one of its most picturesque gorges — which is laced with a copper-green colored lichen (fungus) — the Copper Canyon region was created in volcanic rock by seismic activity and erosion. Rivers born from summer thunderstorms flow from the Sierra Madre Occidental mountains in Chihuahua state and water a lush scenery of verdant meadows and forests of pine and oak trees.

Through these lands walk — or run — the Tarahumara. The world's strongest long distance runners, they can run 100 miles non-stop for hunting and sports. Scattered over 10,000 square miles, the Tarahumara (or *Rarámuri* in their own language) are probably the most isolated and primitive indigenous tribe in North America.

We'll explore Copper Canyon on the "Chepe" — the Chihuahua al Pacífico railroad. Crowned "the most dramatic train ride in the Western Hemisphere" by Reader's Digest magazine, the Chepe climbs 7,300 feet in 122 miles. There's a mile-long tunnel, a horseshoe-bend inside a mountain, and a loop where the track crosses itself. Proposed in 1872 as a shorter route to connect Kansas to the Pacific, the railroad opened in 1961 and runs between Los Mochis and Chihuahua.

Come discover Copper Canyon.

Sincerely,

Bernardo Balderrama Garcia

SEA OF CORTÉS

Our journey begins at the Sea of Cortés, also known as the Gulf of California. Called the "Aquarium of the World" by Jacques Cousteau, the Sea of Cortés harbors 34% of the planet's marine animals.

The seismic separation of the Baja peninsula from mainland Mexico has created the world's newest, and most fertile, sea. It is home to migrating California gray whales, humpback whales, hammerhead sharks, dolphins, manta rays, marlin, moray eels, turtles and 3,000 other animal species.

LOS MOCHIS

The coastal city of Los Mochis (with the nearby port of Topolobampo) is the western terminus of the Chihuahua-Pacific Railroad, or Chepe. Visitors arrive by air to Los Mochis Federal Airport; by ferry from La Paz; by land or Guadalajara near Mexico City; or by land from the United States via Arizona, California or Texas.

Founded in 1903 by Americans as a sugar cane and railroad town, Los Mochis may mean "place of turtles" in the local Mayo Indian dialect.

Left: Arriving by air over the Sea of Cortés.
Above: Dolphins in Ohuira Bay near Los Mochis.

EL FUERTE

Cobblestone streets decorate this delightful and intimate historical town. Founded in 1563 by conquistadors, El Fuerte (Spanish for "the fort") was a thriving colonial outpost, receiving silver from the mines in 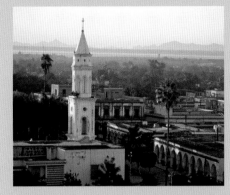 Copper Canyon and sending explorers to Arizona and California.

Zorro — the legendary hero created in a novel — is said to have come from El Fuerte. He was reputedly born in 1795 in a Spanish colonial mansion, now the site of The Posada del Hidalgo hotel. Later in California, he became a masked outlaw, protecting the people with his rapier sword, and wit.

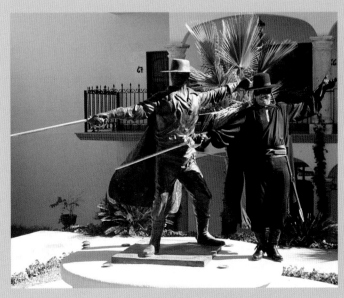

Above and right: Zorro at Posada del Hidalgo.

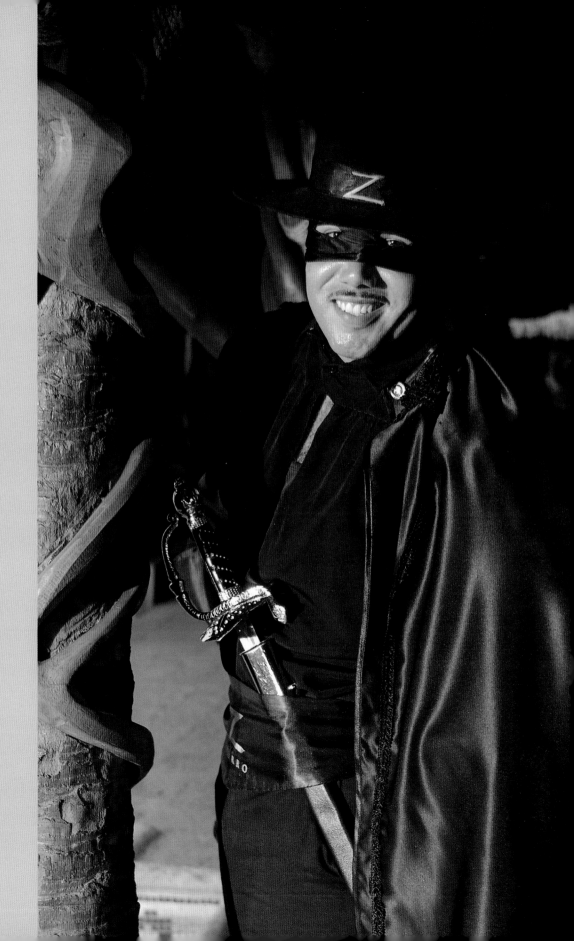

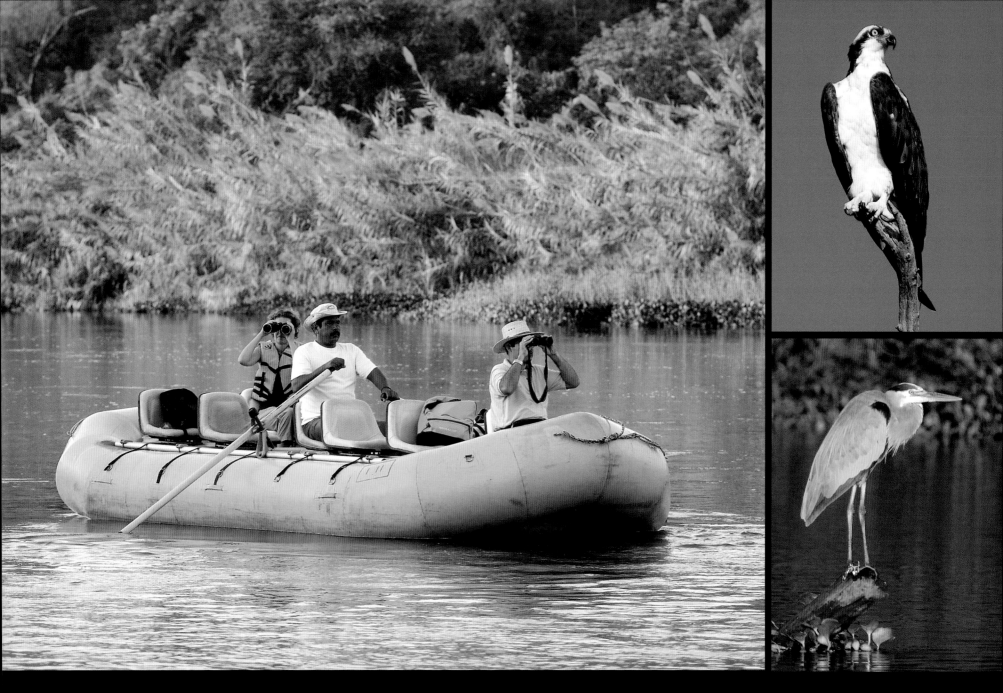

A pleasant rafting trip on the El Fuerte river is great for spotting birds, such as this hawk (top) and egret (bottom).

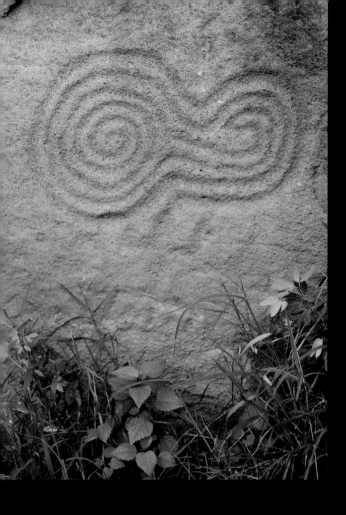

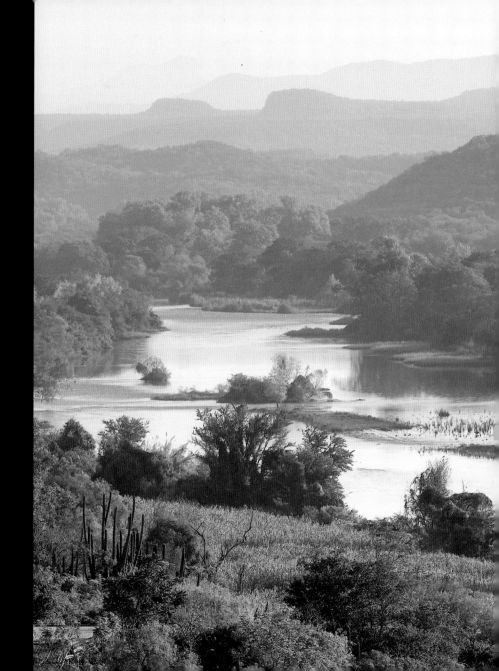

FUERTE RIVER

Many of the Copper Canyon rivers flow west
into El Fuerte river through verdant tropical forests.
Along the river is the Hill of the Mask (*Cerro de la
Mascara*), site of ancient Nahuati (Toltec) petroglyphs
believed to be between 800 and 2,500 years old.

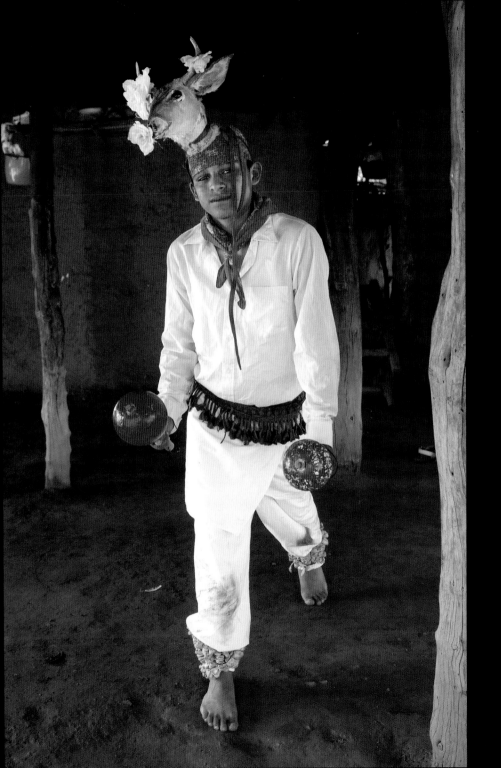

Mayo Indians

Originally living near the Mayo River in Sonora, the Mayo people (*Yoreme* in their own language) are adept at fishing and agriculture. They number around 40,000 and there are 72 Mayo tribes in Sinaloa state.

Left: Mayo indian boy on custom deer dance.

Below: A 17th Century mural at Palacio Municipal depicting Spanish conquistadors raiding the El Fuerte River indian tribes.

Right: A Mayo woman making clay pottery in Los Capomos, near El Fuerte.

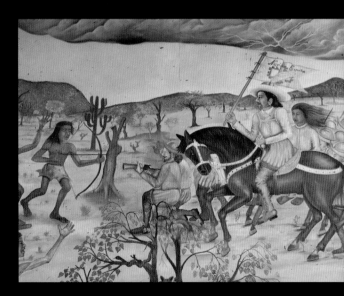

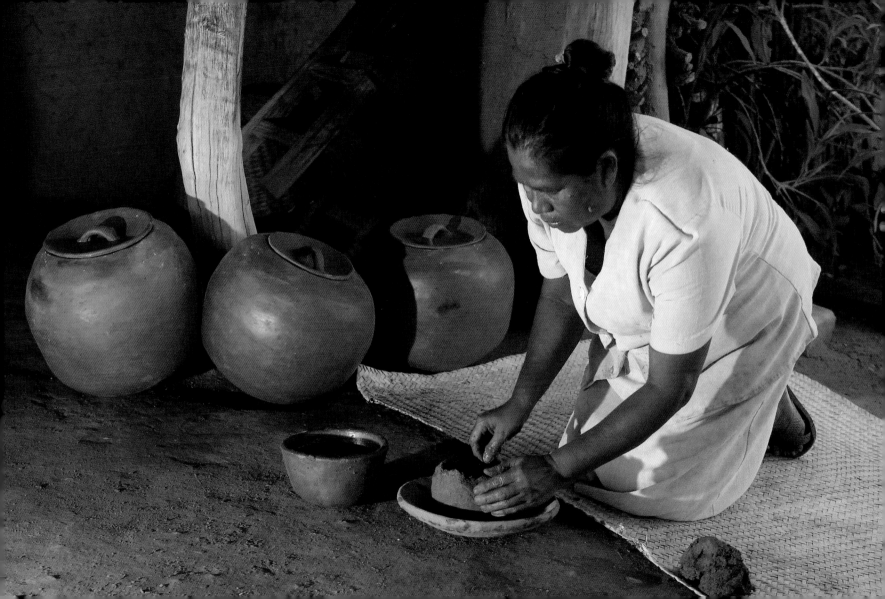

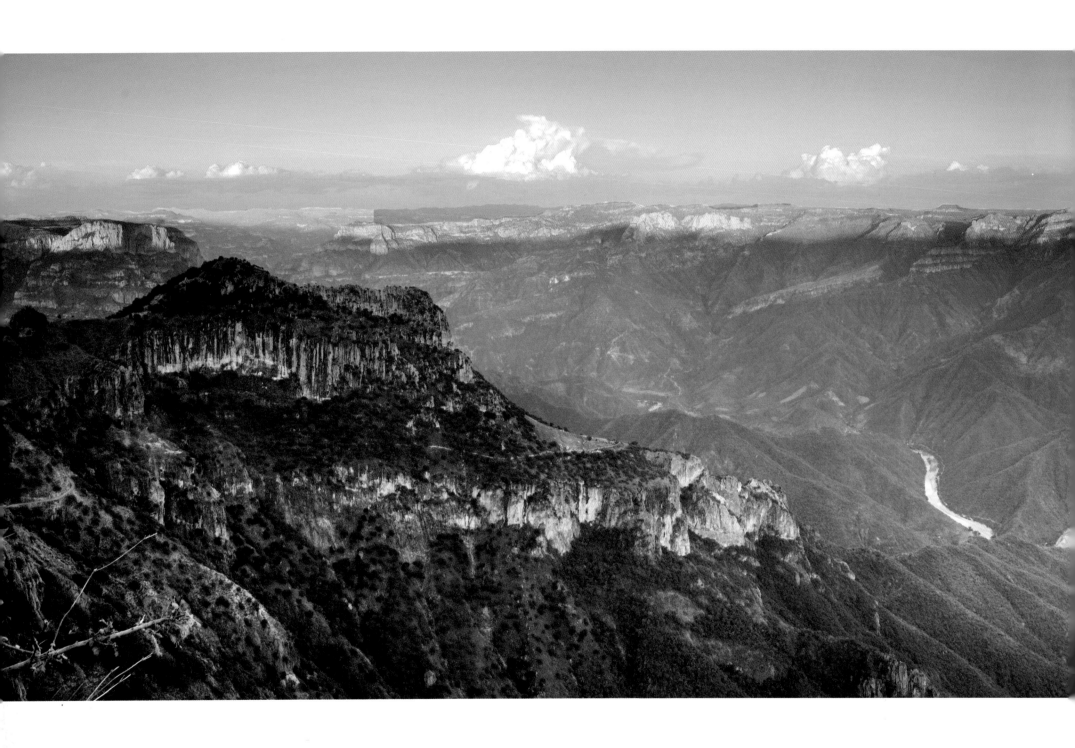

The panoramic view of Urique Canyon and Urique River from Mirador Cerro del Gallego, near Cerocahui.

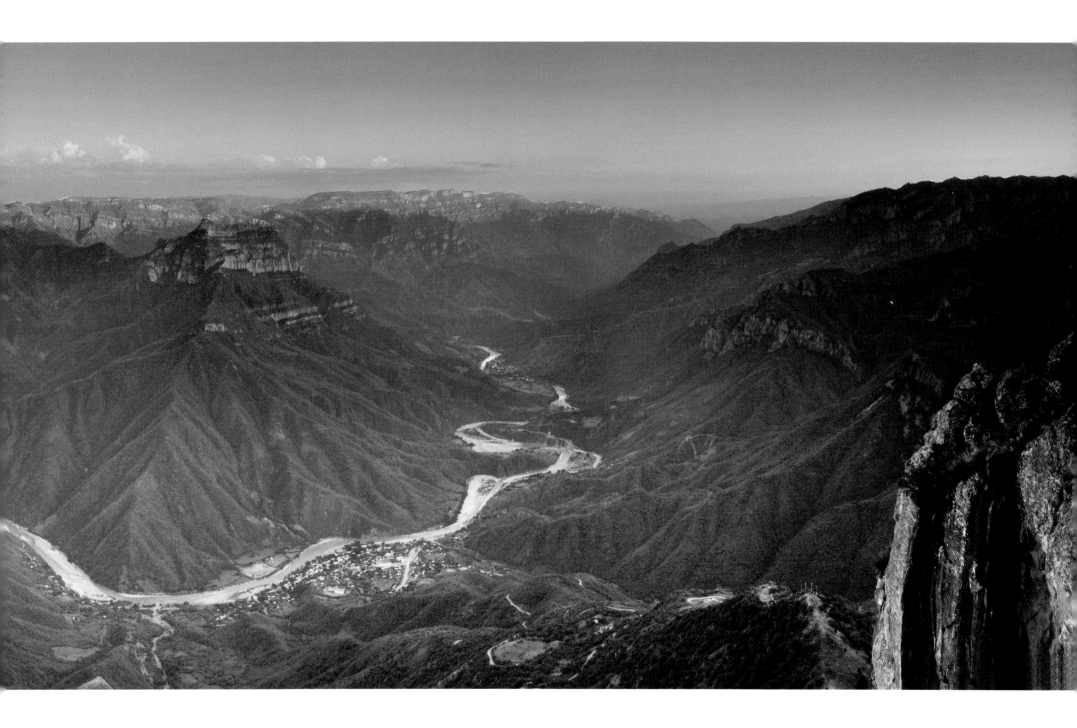

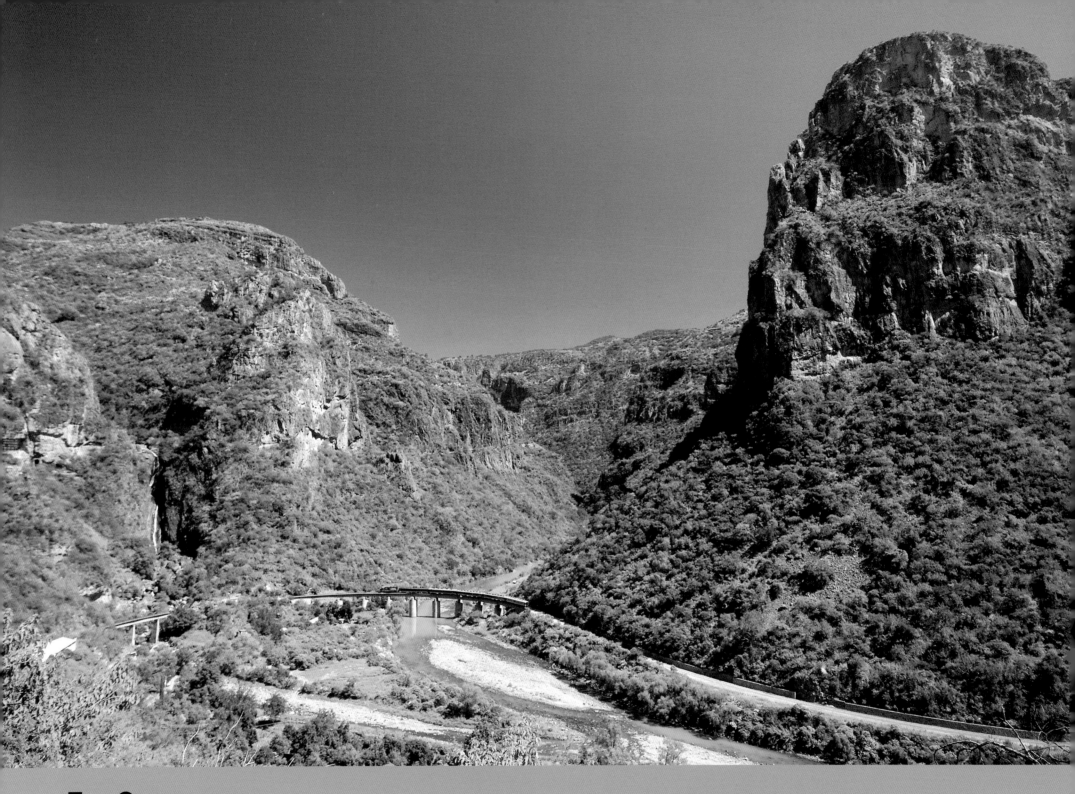

THE CHEPE
The Chihuahua al Pacífico Railroad (or Chepe) burrows through 86 tunnels and traverses 37 bridges. While crossing Temoris Bridge (above), passengers can view the Horse Tail Waterfall (Cola de Caballo).

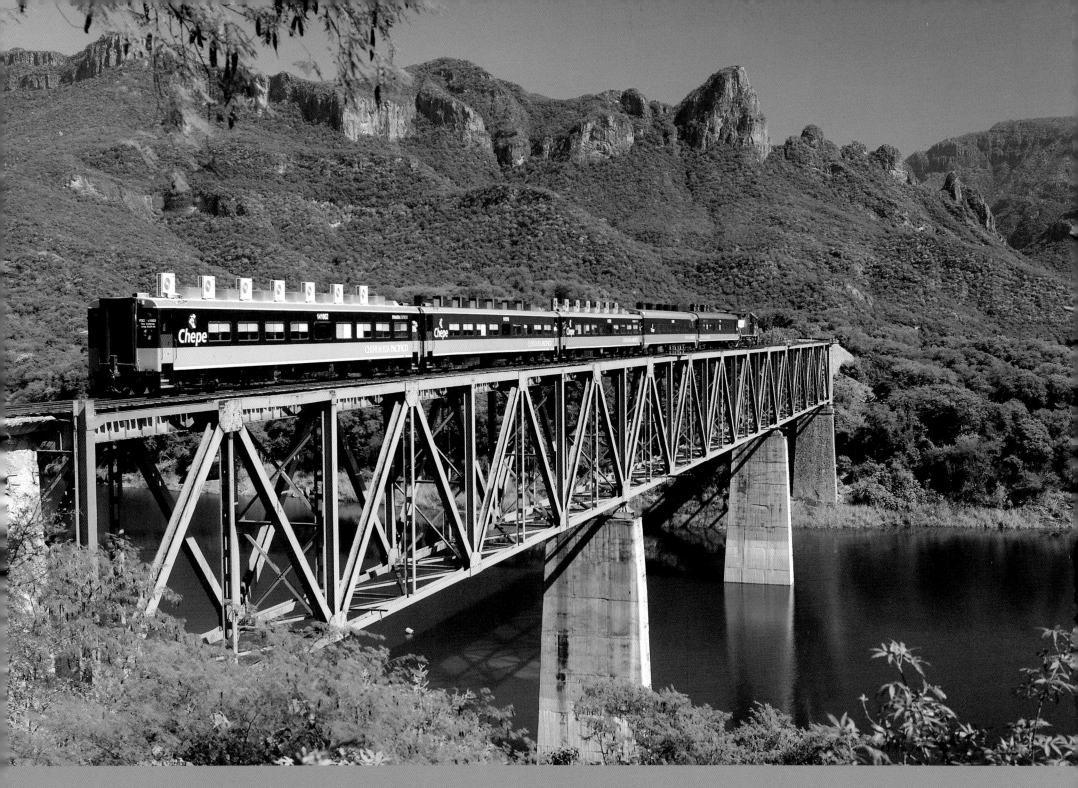

Aguacaliente Bridge over the Chinipas River at Huites Lake (km 748). Crossing Copper Canyon from Los Mochis to Chihuahua, the 400-mile (650 km) railroad trip takes 16 hours.

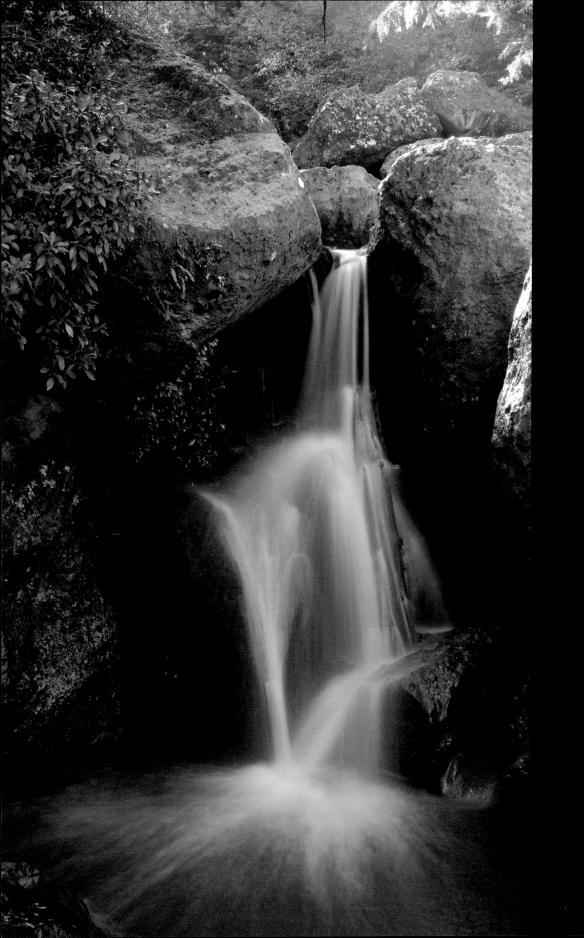

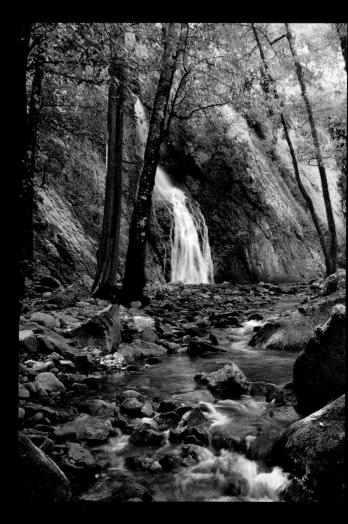

Cerocahui

Nestled in a valley and surrounded by apple orchards, the picturesque mountain village of Cerocahui (elevation 1,670m/5,478 ft.) was first visited by the Spanish in 1679. No doubt they too admired Cerocahui waterfall (left) and Huicochi waterfall (above).

Nearby is Gallego Hill (*Cerro del Gallego*) with the best views of Urique Canyon, the deepest canyon in the system.

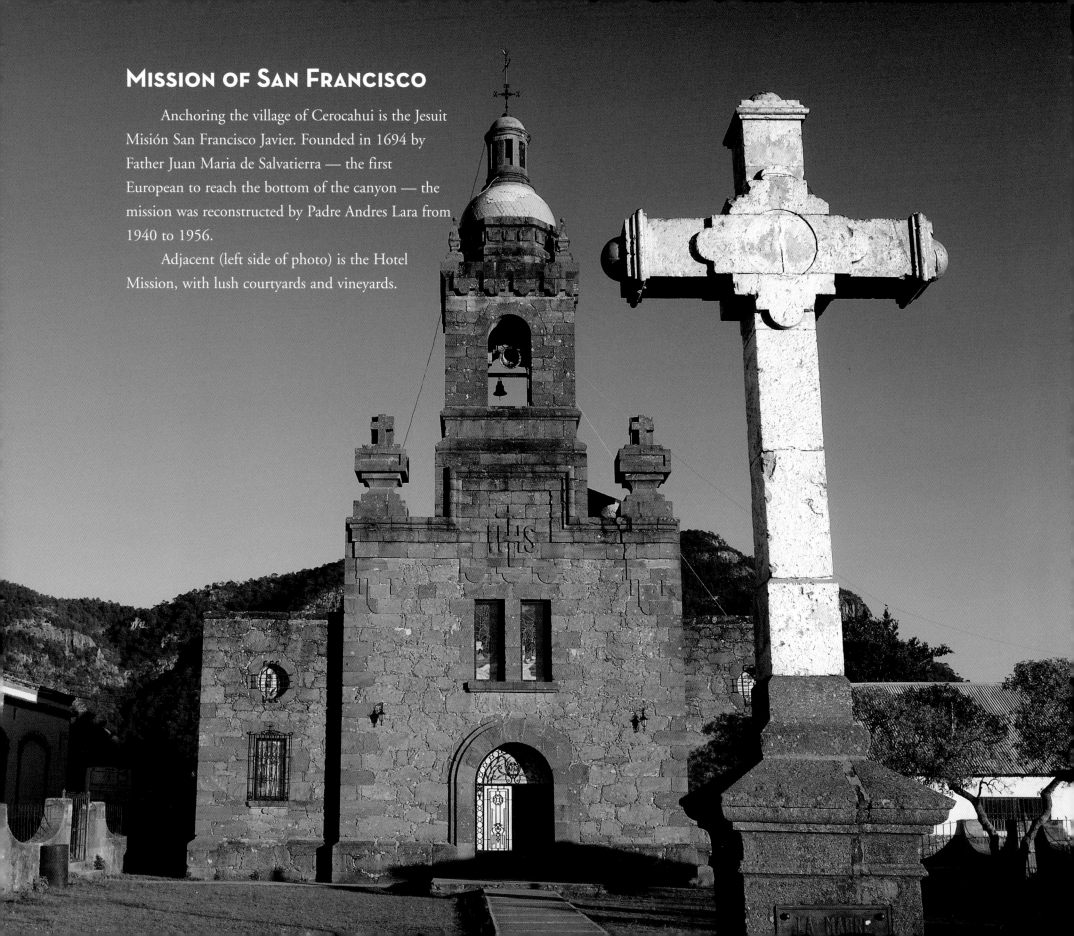

MISSION OF SAN FRANCISCO

Anchoring the village of Cerocahui is the Jesuit Misión San Francisco Javier. Founded in 1694 by Father Juan Maria de Salvatierra — the first European to reach the bottom of the canyon — the mission was reconstructed by Padre Andres Lara from 1940 to 1956.

Adjacent (left side of photo) is the Hotel Mission, with lush courtyards and vineyards.

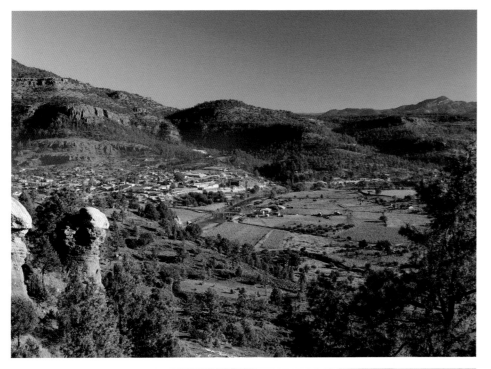

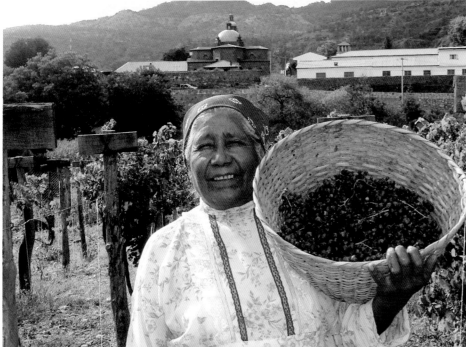

The beauty of Cerocahui. *Top:* Rock walls frame the fertile valley.
Bottom: A woman collects grapes in the vineyards by Mission of San
Francisco Javier. *Right:* Huicochi waterfall near Cerocahui.

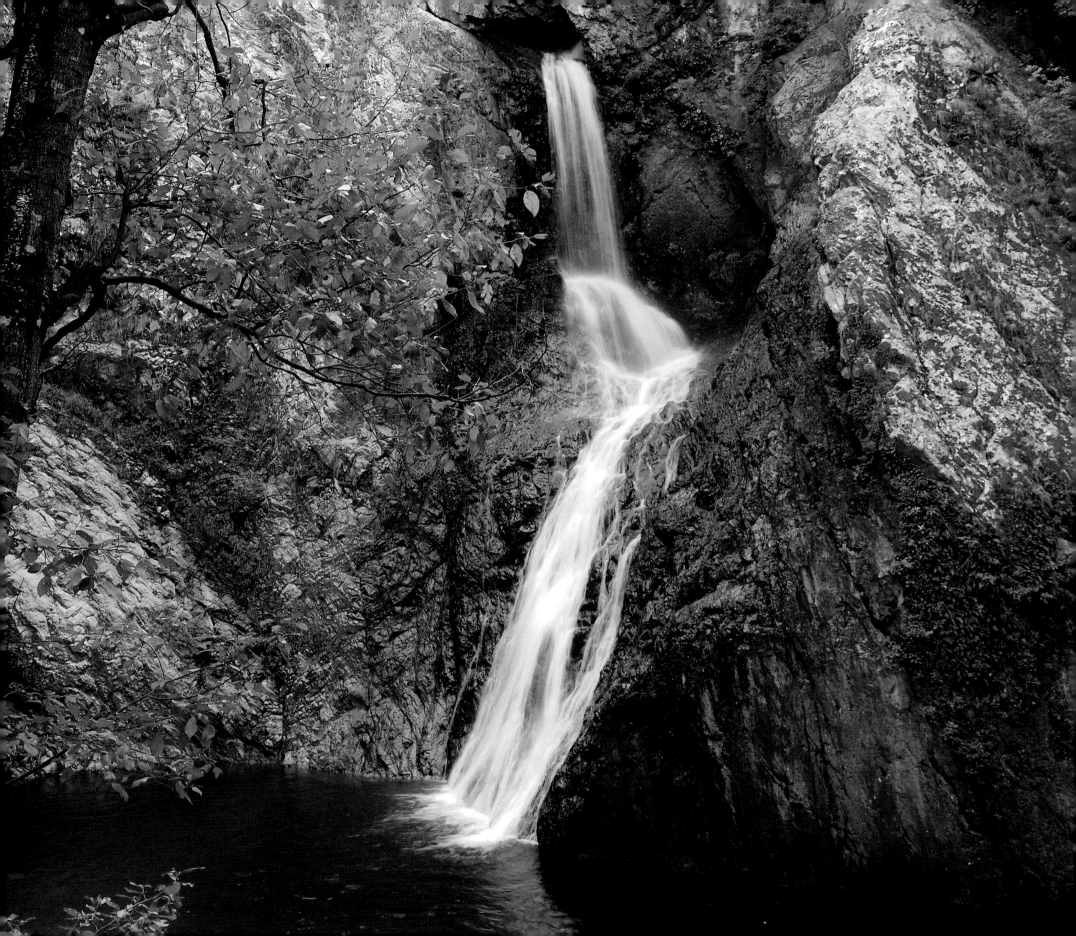

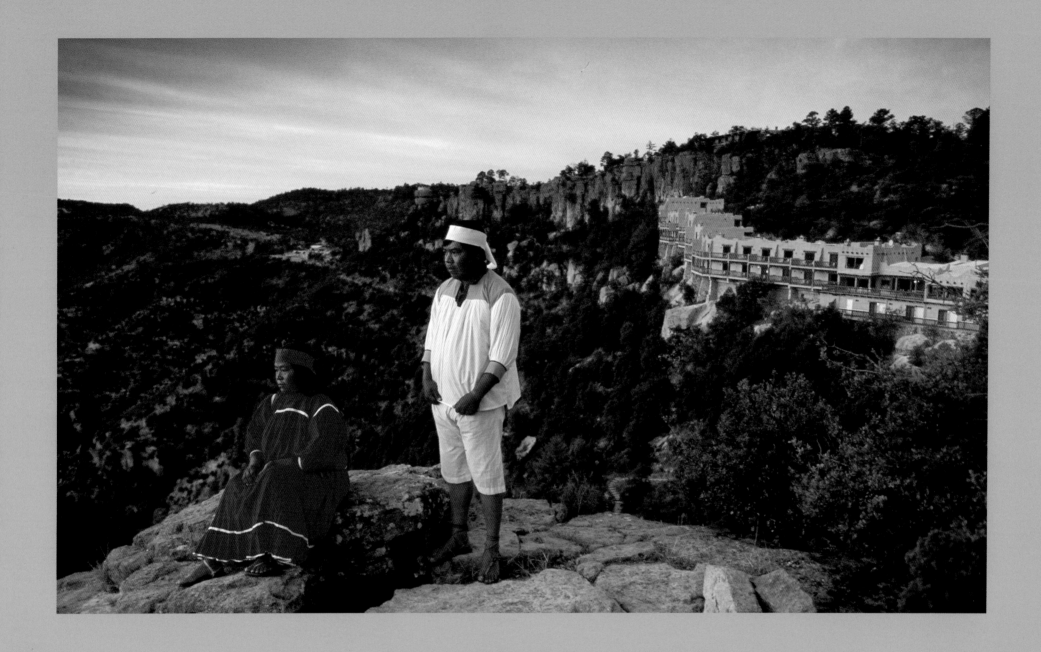

MIRADOR HOTEL

A Tarahumara Indian couple and the Hotel Posada Barrancas Mirador, which is perched dramatically like an eagle's nest on the rim of Copper Canyon at Posada Barrancas train station.

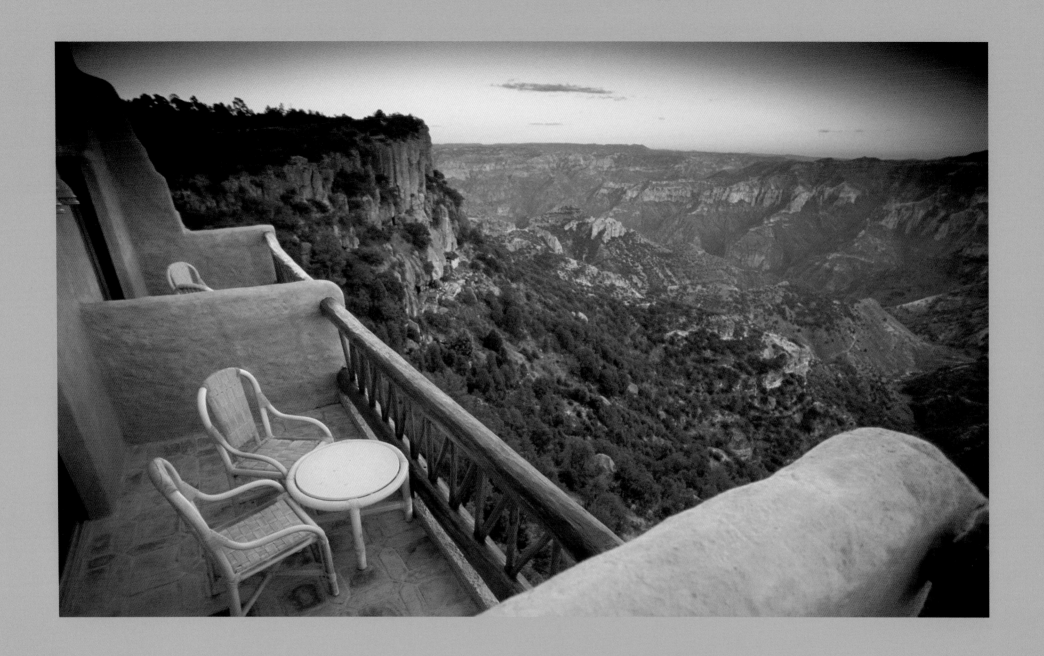

Where else can you sleep with such a spectacular view of North America's deepest canyon?

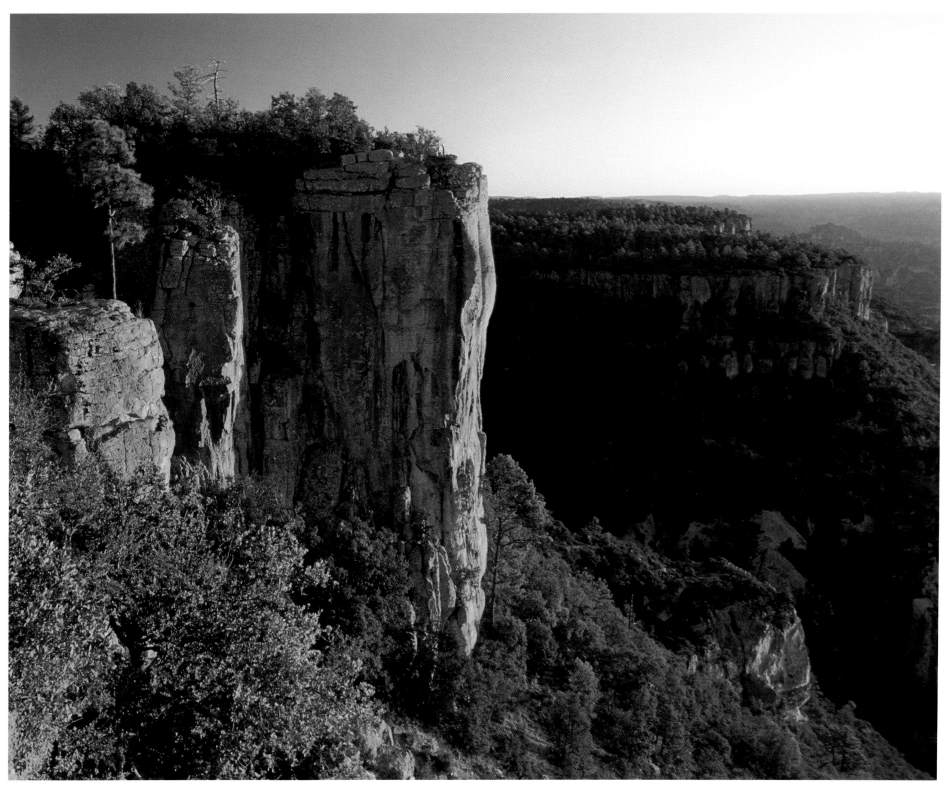

A short walk from the Mirador Hotel brings you to these delightful overlooks.

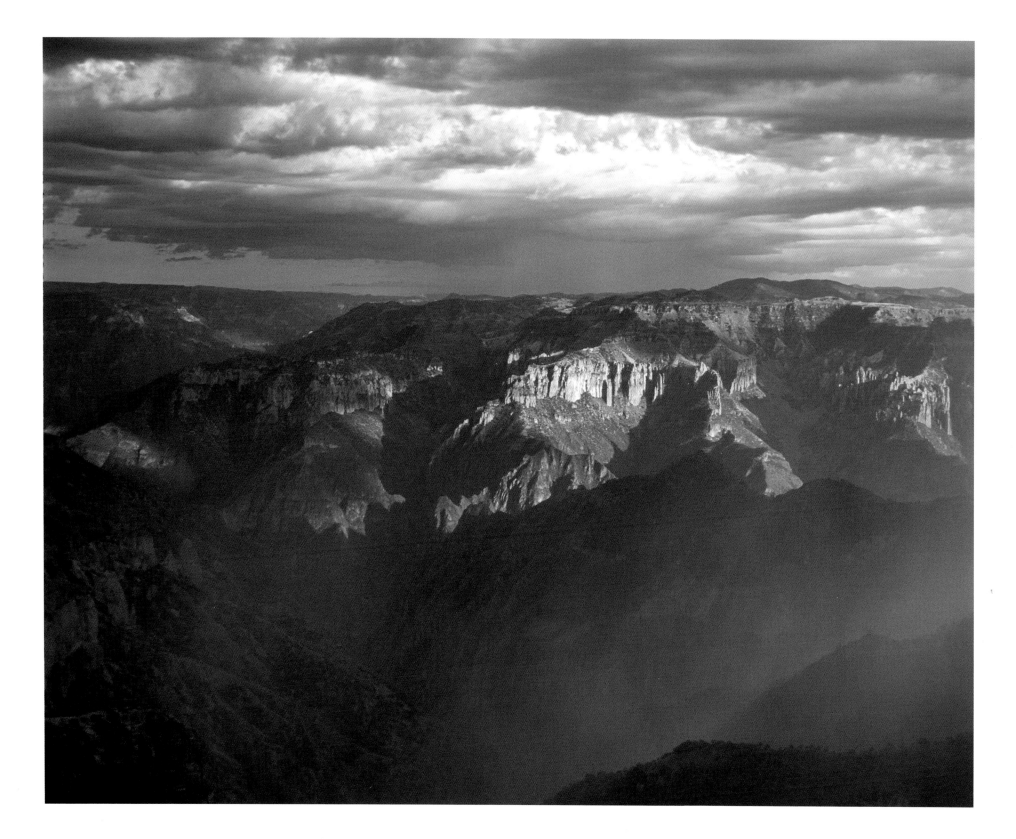

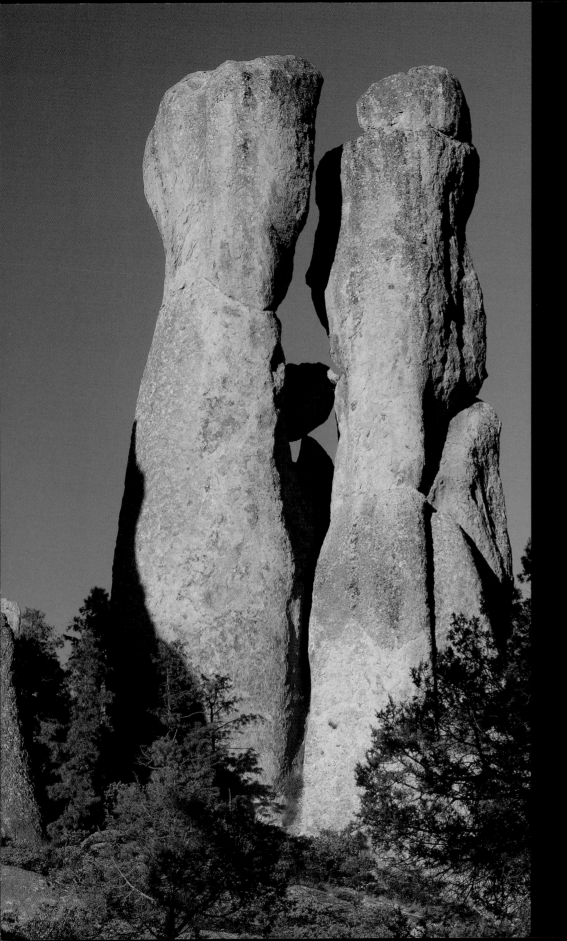

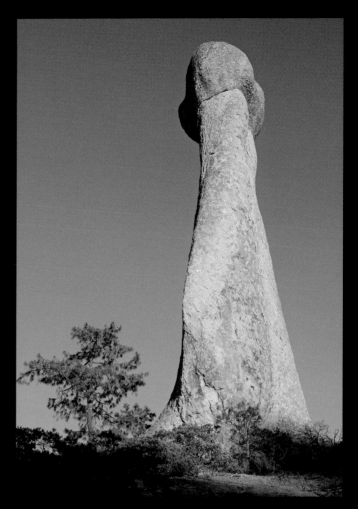

Valley of the Monks

Officially called Valley of the Monks (*Valle de los Monjes*), this area of tall rock formations is more colorfully named by the Tarahumara as *Bisabirachi* — "Place of Erect Penises." Nearby are the Valley of Mushrooms (*Valle de Hongos*) and Valley of Frogs (*Valle de Ranas*), all located near Creel.

Founded in 1907 as a railroad town, Creel was named for a governor of Chihuahua. At 8,071 feet (2,460m) above sea level, nearby Los Ojitos ("the little eyes") is the literal high point of our journey.

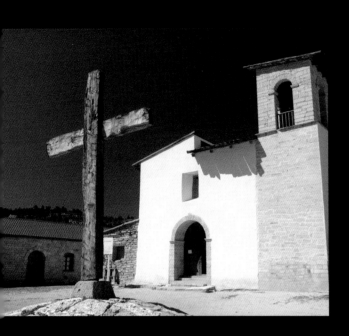

CUSARARE

East of Creel is the mission village of Cusarare. The name is Tarahumara for "Place of the Eagles" as majestic golden eagles used to nest here, although they have now retreated to even more isolated areas of Copper Canyon.

In the center of the village is the "five men" Mission de los Cinco Senores de Cusarare (pictured above), founded in 1752.

A two-mile hike through a pine-oak forest leads to the popular Cusarare Falls (right). Located in a small side canyon to Copper Canyon, the falls drop 100 feet (30m) and are particularly impressive in the rainy season.

Nearby, in the adjacent Tararecua Canyon, is Rukiraso Falls, reached both by hiking or off-road vehicle.

Above: Mission of the Five Men of Cusarare.
Right: Tarahumara women at Cusarare Falls.

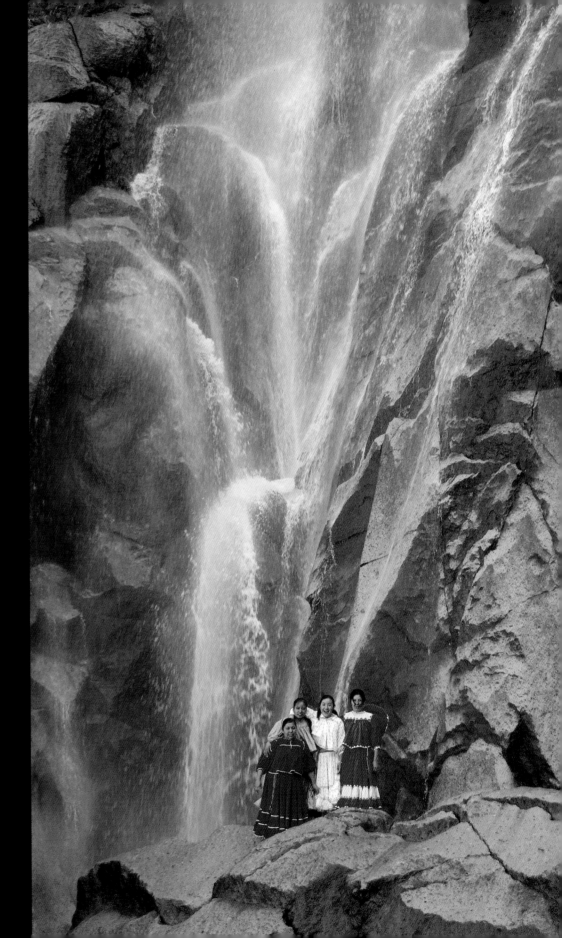

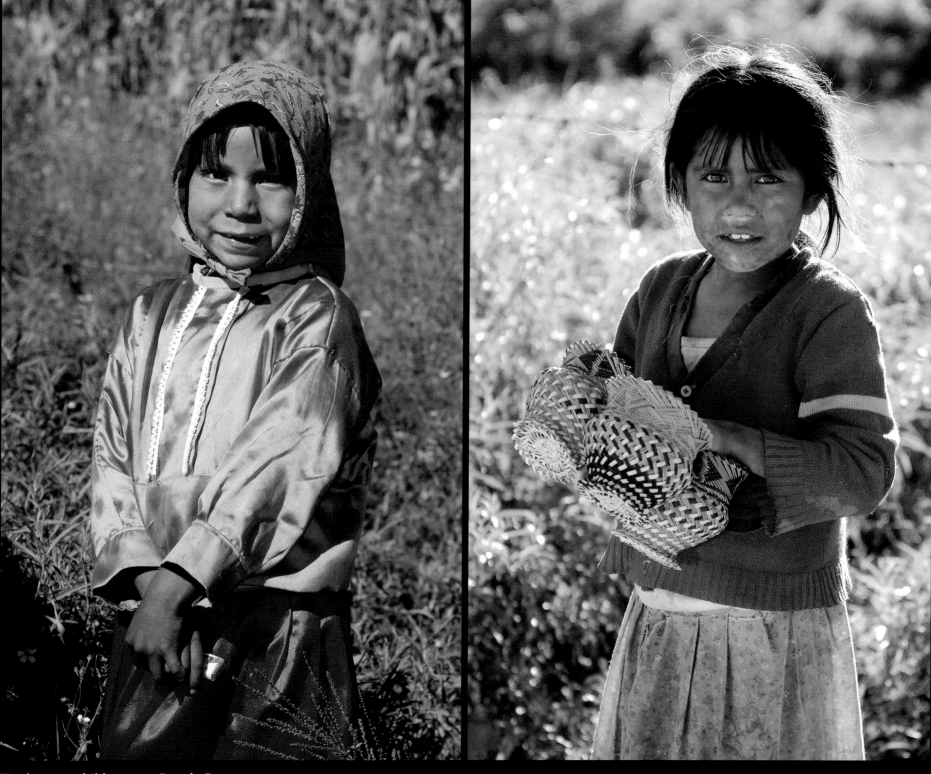

Tarahumara children near Posada Barrancas.

TARAHUMARA

The people of Copper Canyon are famous in their own right. A self-sufficient and semi-nomadic people, the Tarahumara (as named by the Spanish, in their own language, *Rarámuri,* meaning "foot runners") are renowned for long-distance running. Hunters can run over 100 miles (160km) to exhaust prey such as deer. Their skills are displayed in the game *Rarjíparo*, where teams of men run barefoot for 50 to 100 miles for several days while throwing a baseball-sized wooden ball — with their feet.

Numbering around 50,000–70,000 and living in the rugged canyon landscape, the Tarahumara are one of the largest and most isolated and primitive Native American tribes on the continent.

Women wear brightly colored clothes and men can wear traditional baggy shorts. Although family groups can be dispersed over many miles — due to the hunting, gathering and farming — the Tarahumara value human relations over belongings.

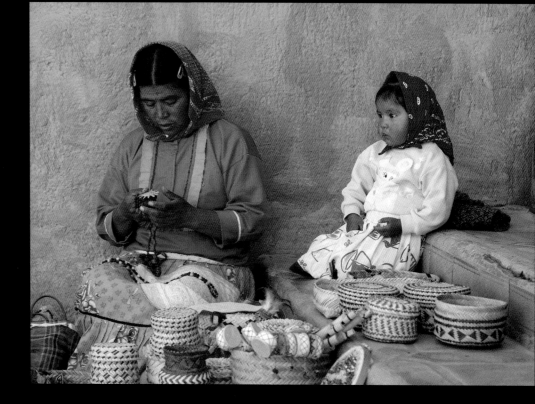

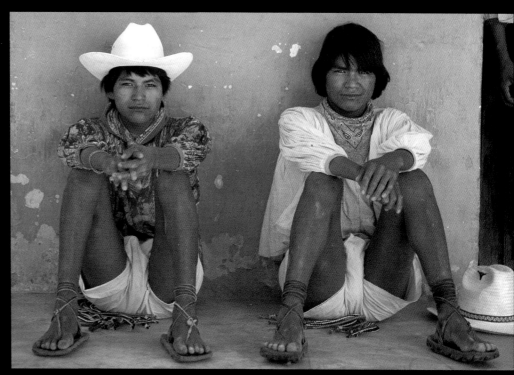

Above: Tarahumara woman weaving pine needle baskets with child.
Below: Tarahumara boys.

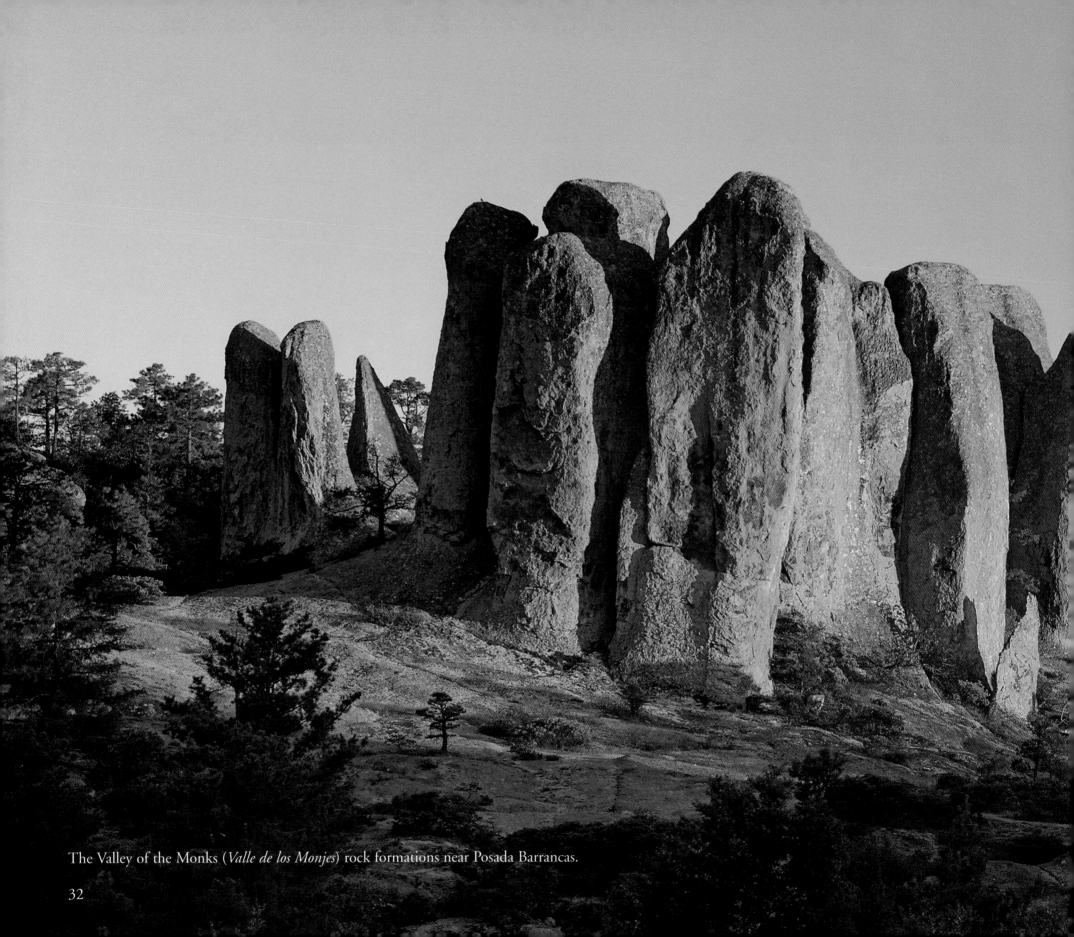

The Valley of the Monks (*Valle de los Monjes*) rock formations near Posada Barrancas.

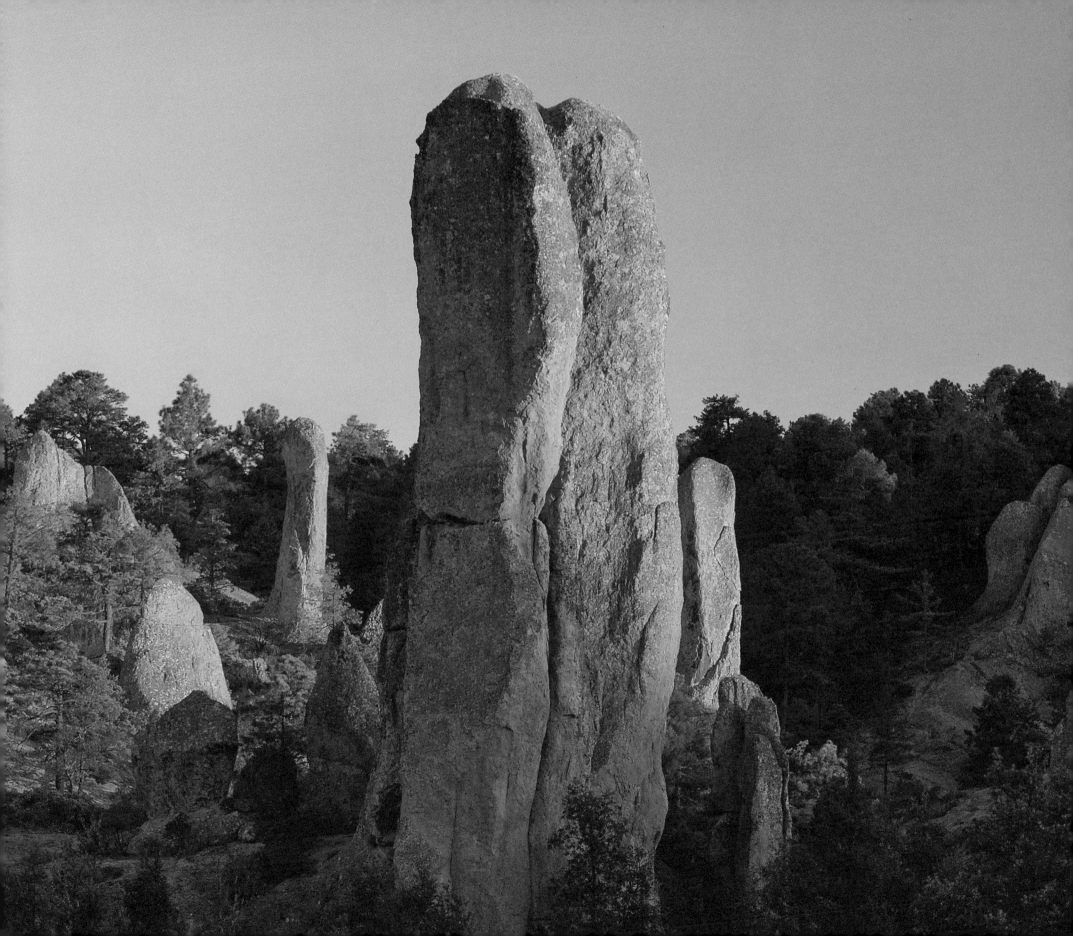

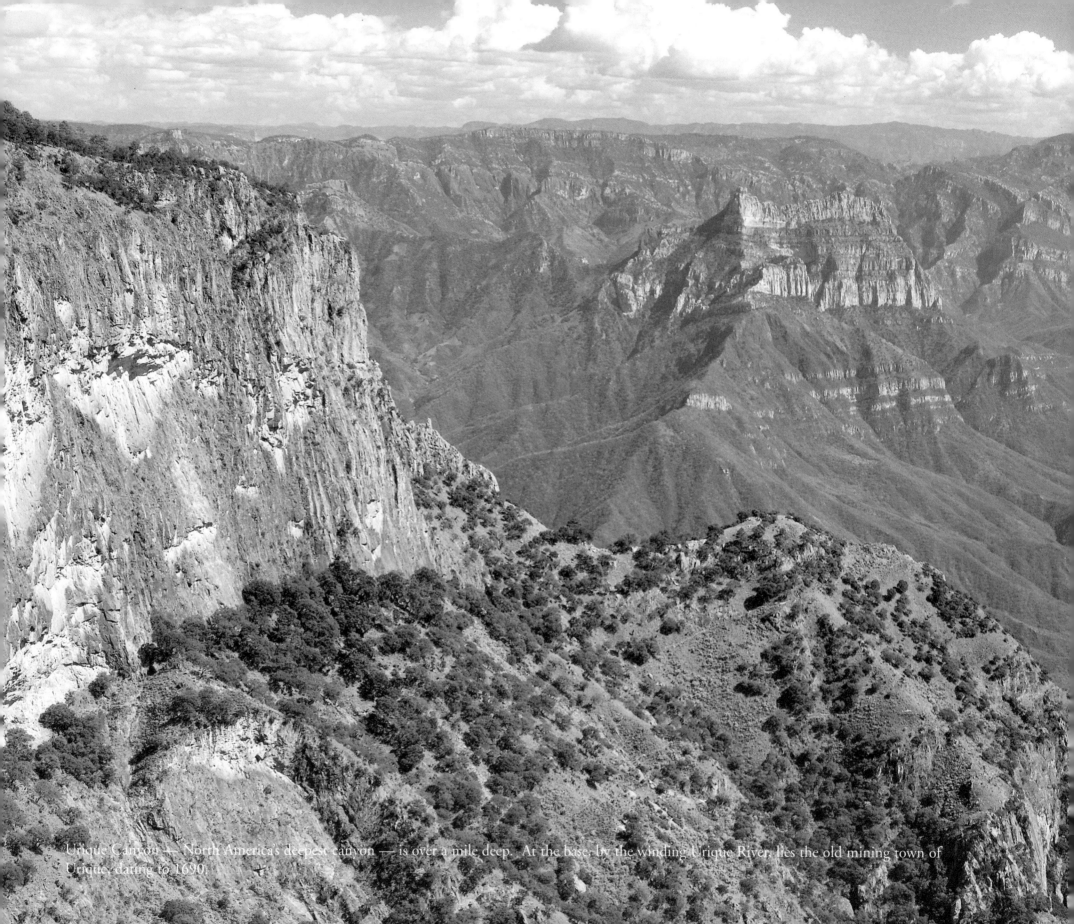

Urique Canyon — North America's deepest canyon — is over a mile deep. At the base, by the winding Urique River, lies the old mining town of Urique, dating to 1690.